THE MOTHER OF ALL JOURNEYS

THE MOTHER OF ALL JOURNEYS
DINU LI

NARRATION BY YEUK LING LI

ESSAYS BY

LISA LE FEUVRE

MARK SEALY

dewi lewis publishing

What we call past is somehow similar to what we call abroad. It is not a matter of distance, it is the passage of a boundary.

Chris Marker (Film Maker)

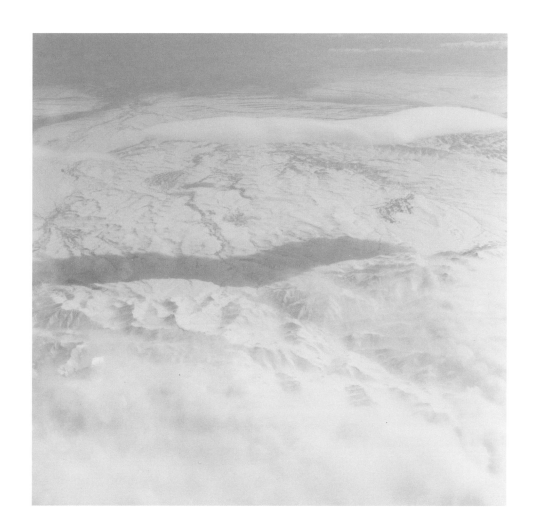

One winter's day in 2001, I was helping my mother clean her house. I busied myself with the dusting and vacuuming, working my way through the house. By the time I got to her bedroom, I found my mother going through her belongings: family snapshots, letters, an assortment of pocket-sized calendars, old diaries, scraps of paper with dates and notes written on them. It occurred to me that although she and my father lived in a reasonably sized house, she had very few material things. Apart from half a wardrobe of clothes and shoes, it seemed that most of her treasures could fit in a biscuit tin. With so few belongings, I wondered if perhaps the things most important to her were stored inside her head?

Looking at these small mementoes triggered my own memories—back to 1988, when, in my early twenties, I went for the first time to visit my 'ancestral' home. I wanted to see the house my mother had spoken about so often, and the village my parents had reluctantly left behind in the mid 1950s, at the time of China's Great Leap Forward. As soon as I arrived, I was surrounded by people. Everybody wanted to know if I was the son of Yeuk Ling and Yuk Cho, such was my resemblance to them. I was taken to the house where my parents had lived as a young married couple. On a wall inside was a large frame displaying an assortment of photographs: my parents, grandparents, siblings, uncles, aunties and cousins, all mixed together. Some pictures were black and white, and faded, whilst others were a little more recent, in colour and sent back from the West. It felt like being inside a museum, everywhere I looked were things belonging to my parents. Scattered on a shelf were drawings, exercise books, comics and romantic novels, and in them the signatures they had scribbled as teenagers.

That memory invoked yet another memory, transporting me back to my own childhood growing up in Hong Kong. At the age of five, I had a fortnightly agreement with my mother that in return for bedtime stories I would tidy her dressing table. It was covered with Chinese ointments, talcum powder, small bottles of perfume and sandwiched between the table top and a glass cover were family photographs. Sometimes she would slide the photographs out from under the glass, to help illustrate her stories—oral histories about her life and the lives of other family members. Far from sending me to sleep, they would send me on a journey. I would close my eyes and create imaginary scenarios, images to accompany her tales.

That evening in 2001, I made a new agreement with my mother—to travel with her and visit the sites of her memories. Memories that had also become my own. I wanted to catalogue them, from as far back as she could remember to as near the present as possible. I wanted to compare the actual with what I held in my imagination. It was time to go on another journey, a journey about a lifetime.

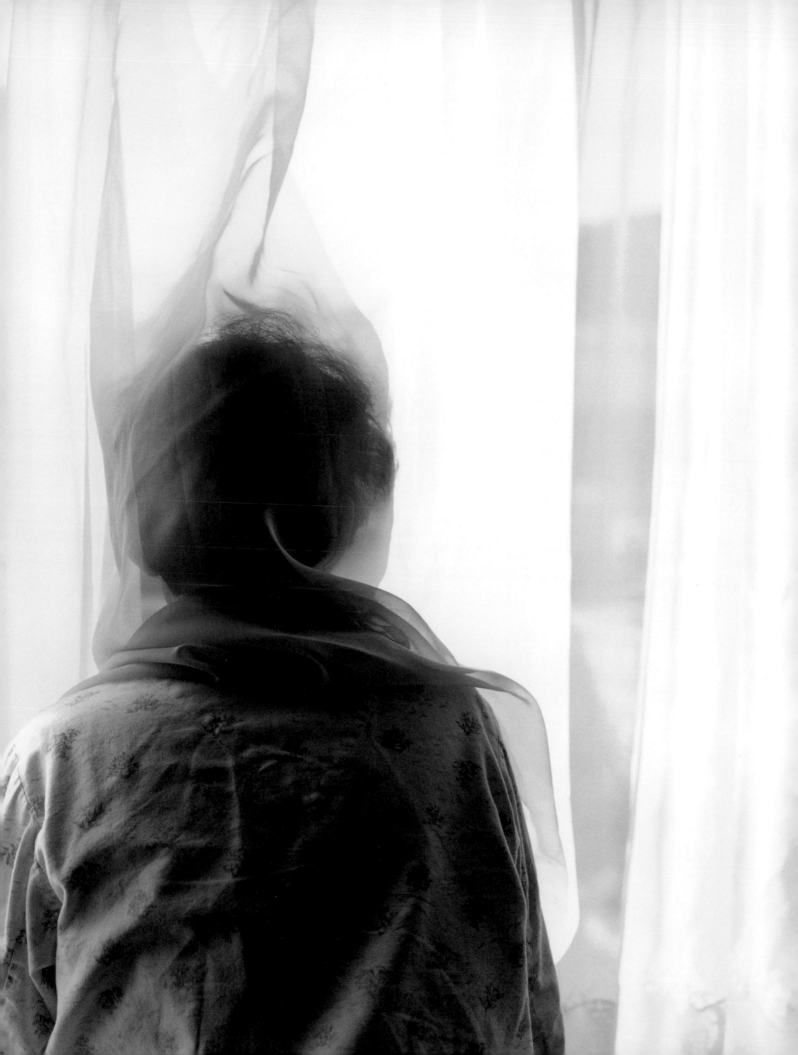

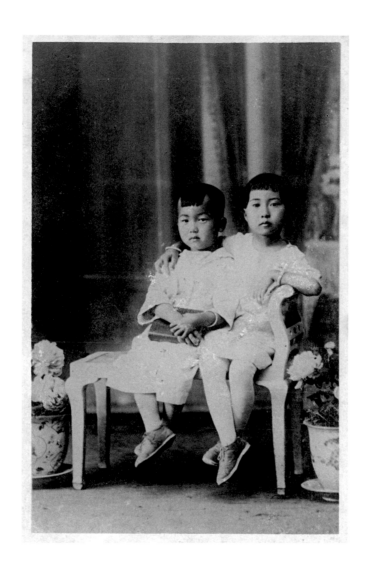

Granddad showed me the way to San Francisco. He pointed
and said "this is the path I'll take."

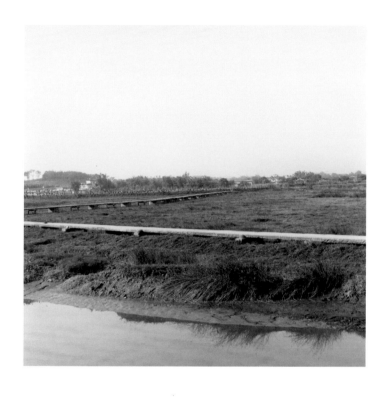

I was always in poor health as a young girl. Everybody in my village thought I had inherited a misfortune from my past life. My mother thought my luck might change if I got married. Our relatives set out looking for a nice boy from a respectable family. There were one or two local boys, but they lived in mud huts. Being quite fussy about cleanliness, I was advised not to bother with them. A distant aunt knew of one house in another village that had patterned tiled floors and decided your father would be the ideal boy.

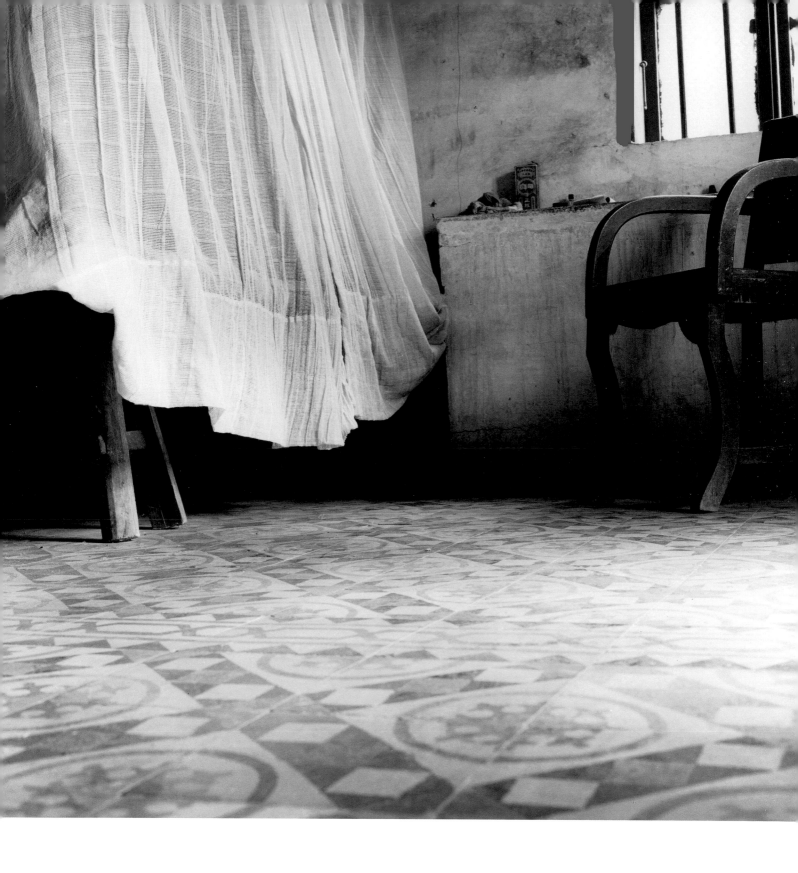

I lost my grandfather when I was 3 and my father when
I was 5. Granddad contributed large donations to help build
schools in our towns and villages. When he died, hundreds
of students past and present turned up, gathering with family
and friends. Many people took turns to carry his coffin
whilst others carried flags or played instruments. Grandma
explained if we all walked together with granddad, his spirit
would always find his way home.

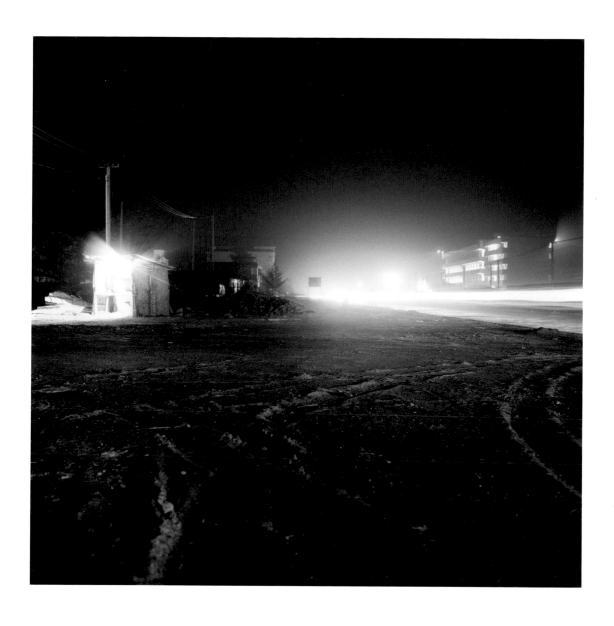

My girlfriends and I came here quite a lot. They'd go diving
into the river, but I'd always stay behind. I couldn't swim.

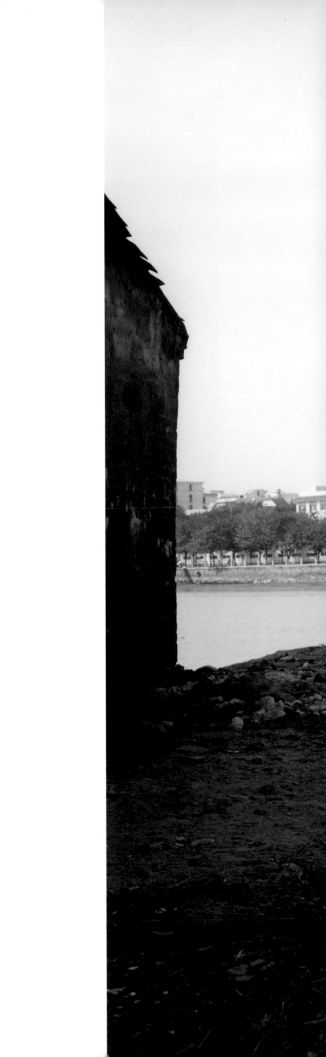

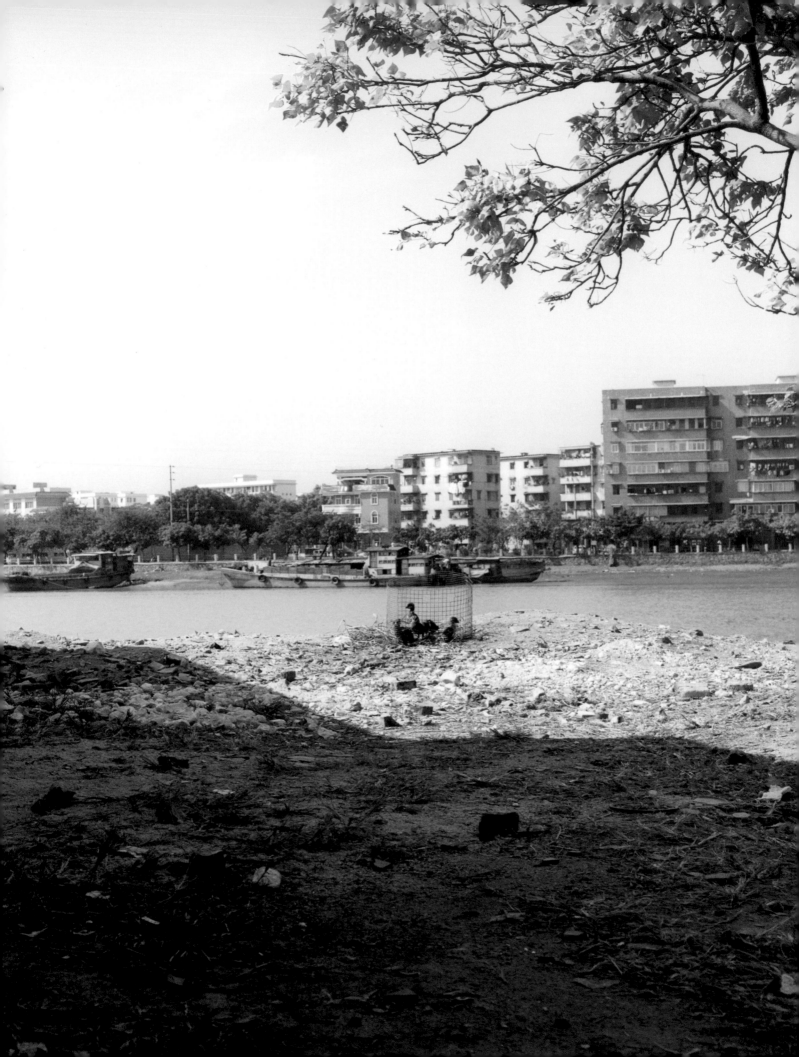

I was the first girl to get engaged. Your dad used to wait for me after school, but there were other boys interested too. They used to throw scrunched up paper balls at me with their names written inside.

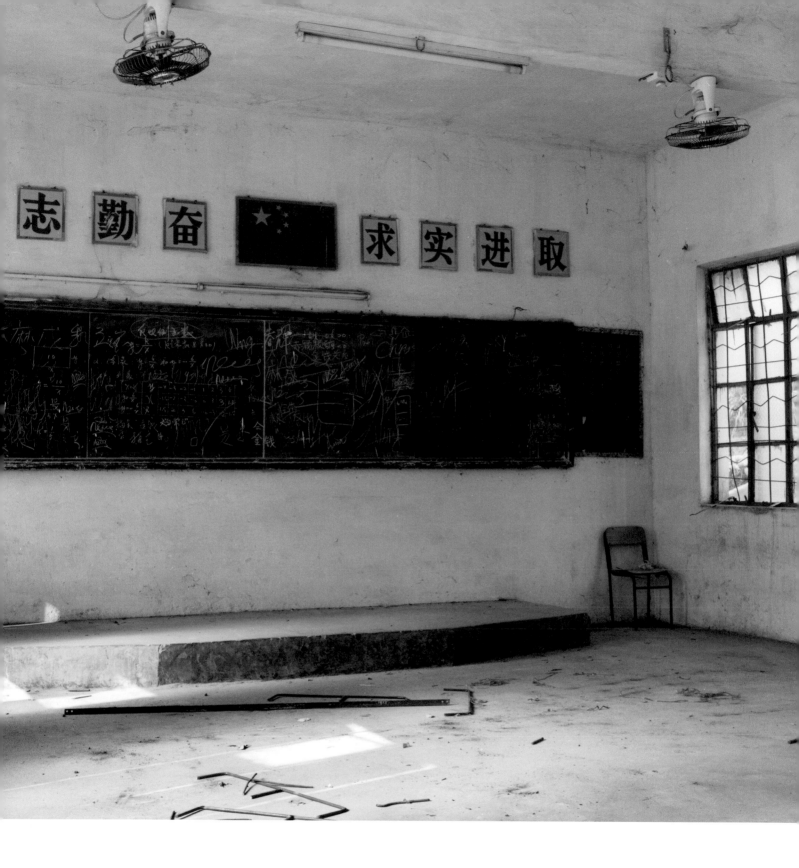

Here's where it all started for me. We had a record player and were the only ones using white tablecloths.

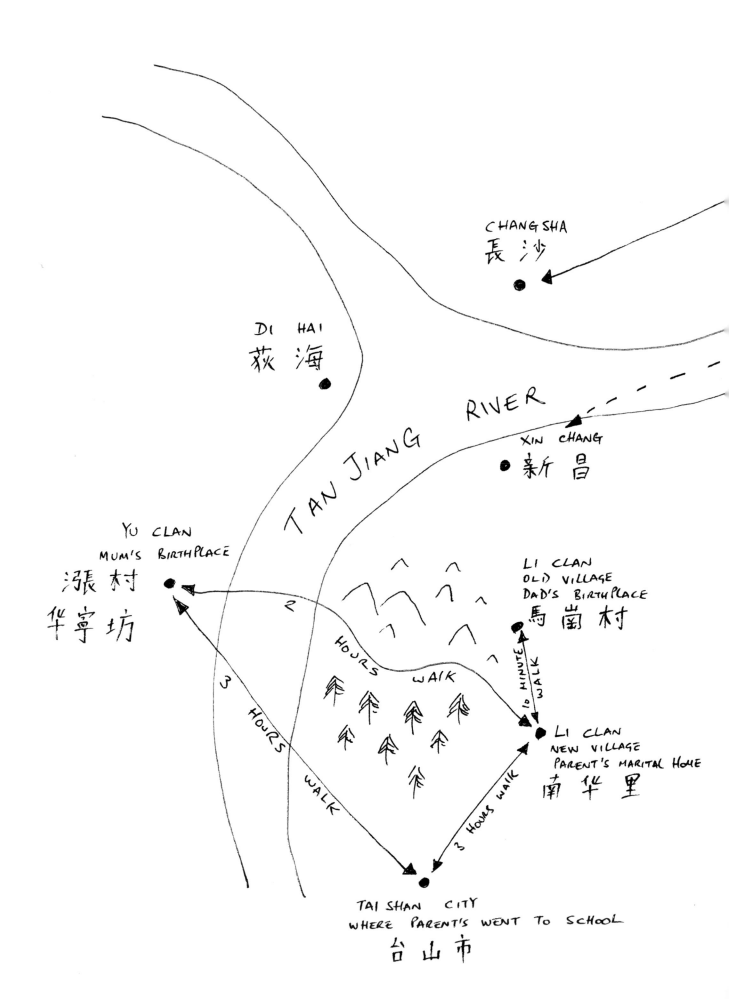

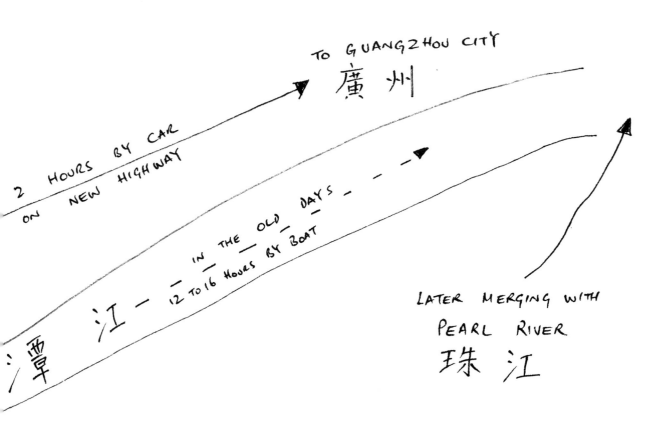

TO GUANGZHOU CITY
廣州

2 HOURS BY CAR ON NEW HIGHWAY

潭 江 — IN THE OLD DAYS — — — — 12 TO 16 HOURS BY BOAT

LATER MERGING WITH PEARL RIVER
珠 江

MAP OF KAIPING
GUANGDONG PROVINCE
SOUTH CHINA

開 平

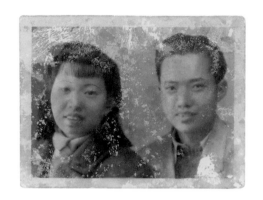

At least 30 clan members were involved on the big day. I was escorted on a sedan chair, but behind me were men carrying brand new furniture. I could see tables, chairs, a wardrobe, a set of leather chests and even a record player.

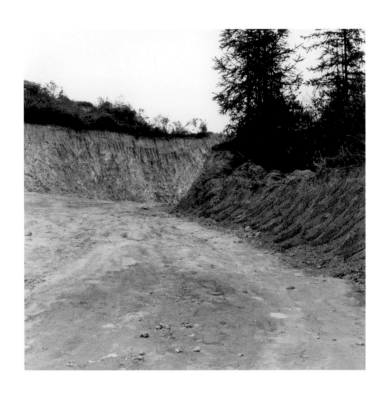

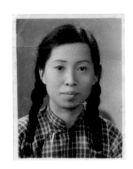

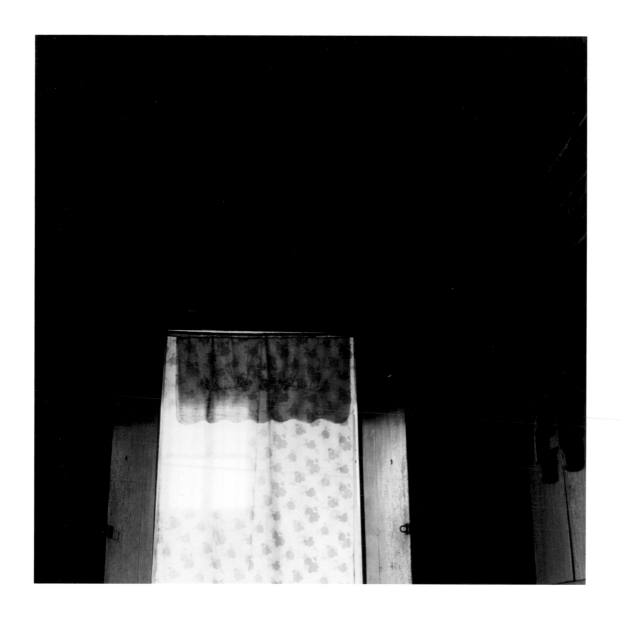

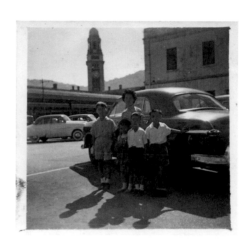

Your father and I both had jobs making underwear. He worked in the factory stitching English words into the waistbands on men's pants. I brought work home, cutting loose threads from bras and breast feeding Chun Yu at the same time.

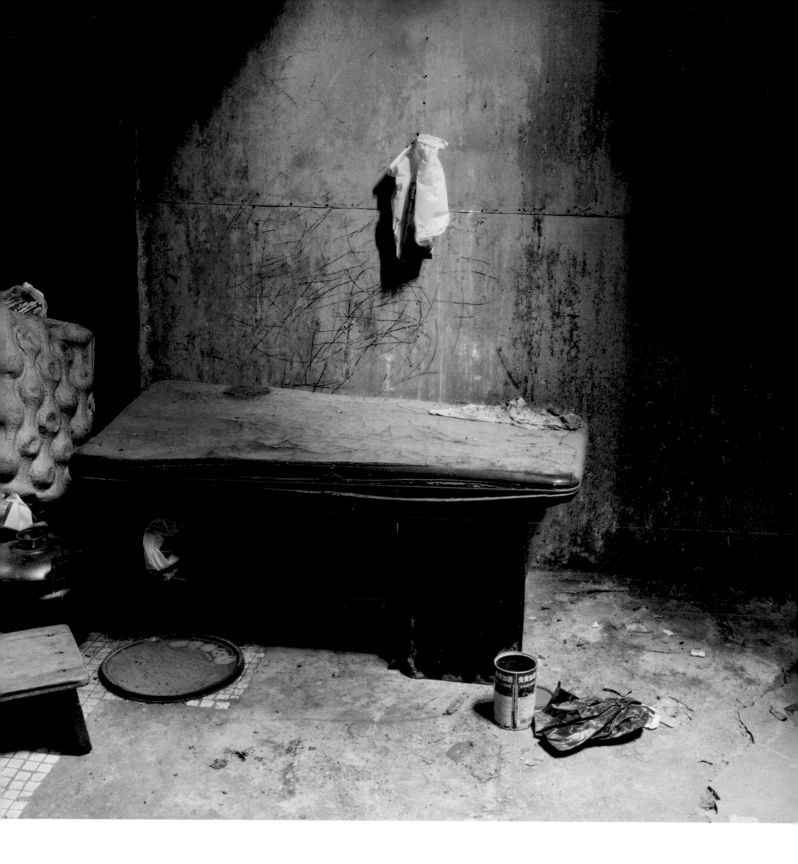

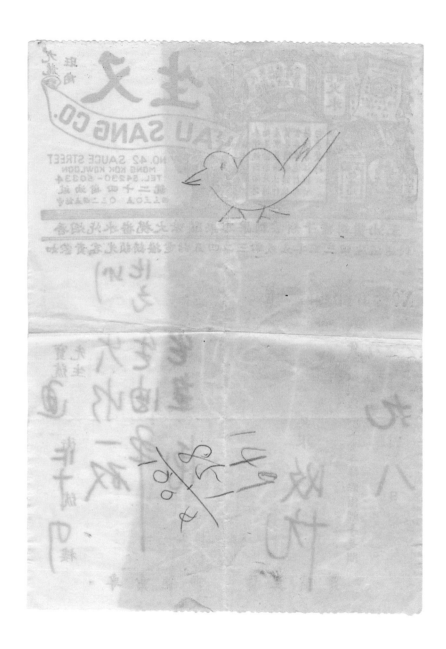

King Yu was a child labourer for a tailor. He was based on the Hong Kong side and was rarely given any time off. Whenever possible, I would wait for him with homemade soup.

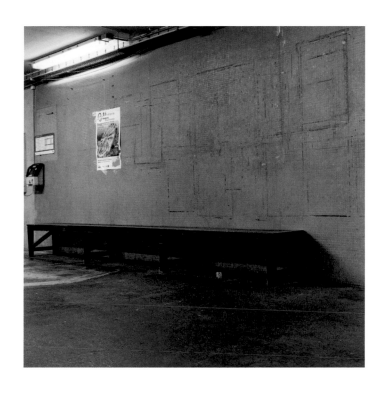

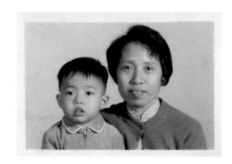

The nurse helping to deliver you looked overworked. She took her frustrations out on me, shouting "why have another one when you have so many already?"

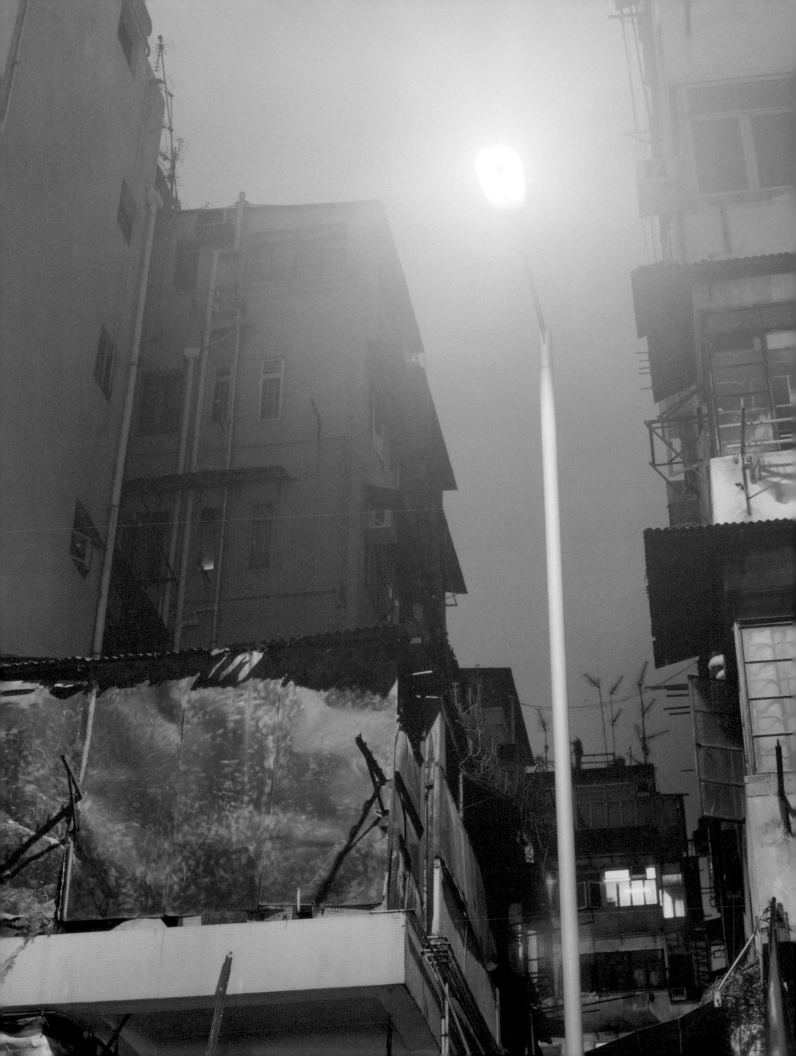

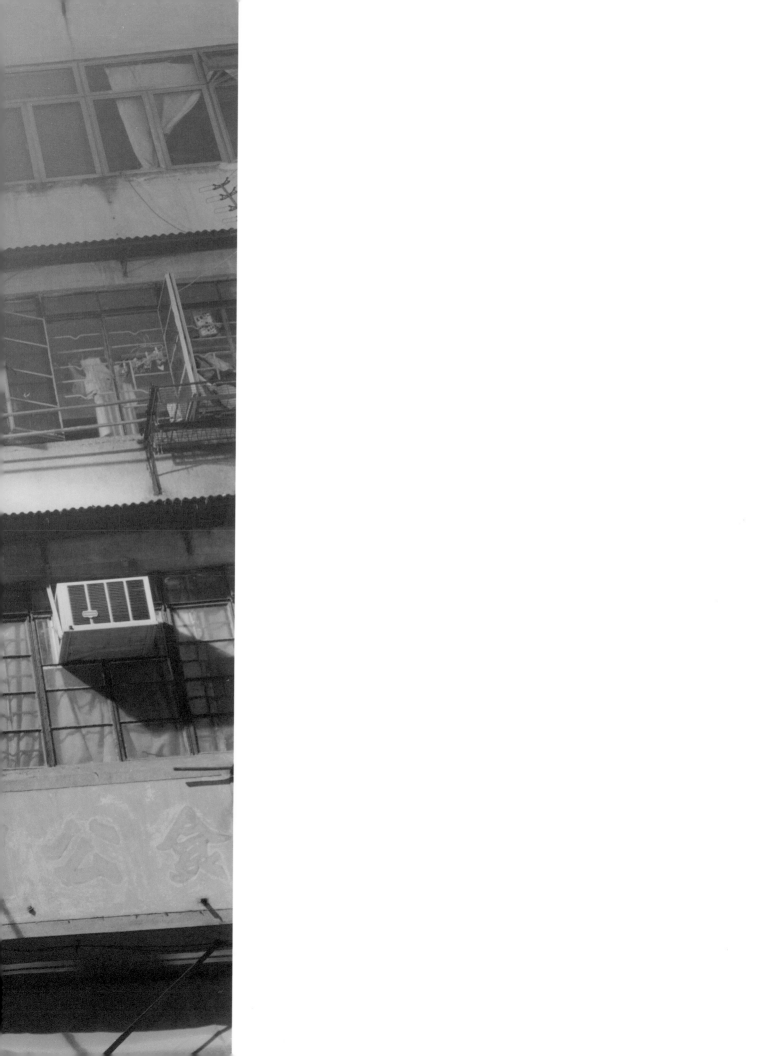

Your brothers would take you to see James Bond. Luina
would take you to see Tony Curtis. But I would always take
you to see love stories. Whenever the stars kissed, I had
to cover your eyes.

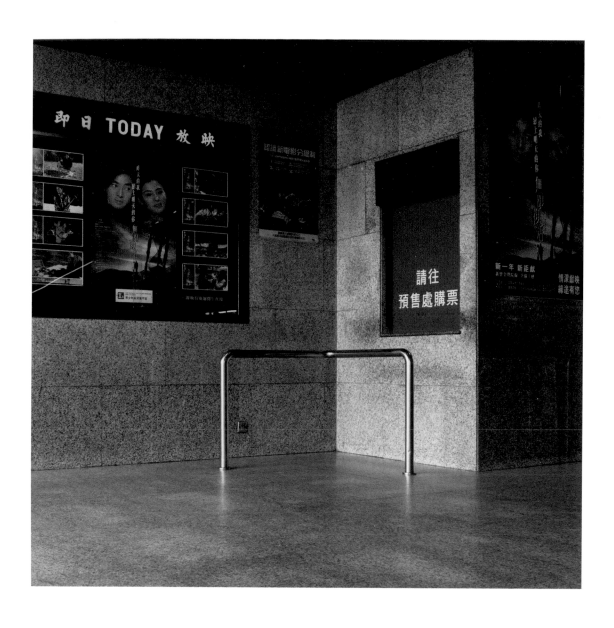

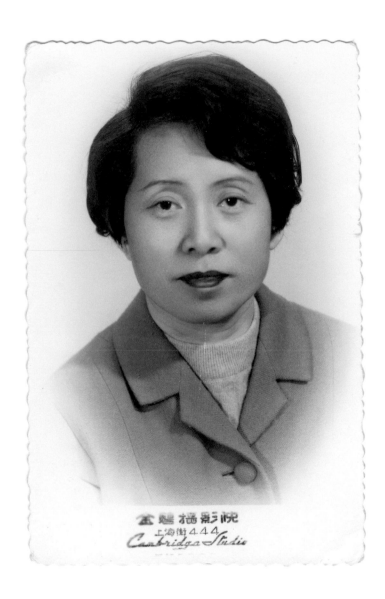

玉豐攝影院

上海街444

Cambridge Studio

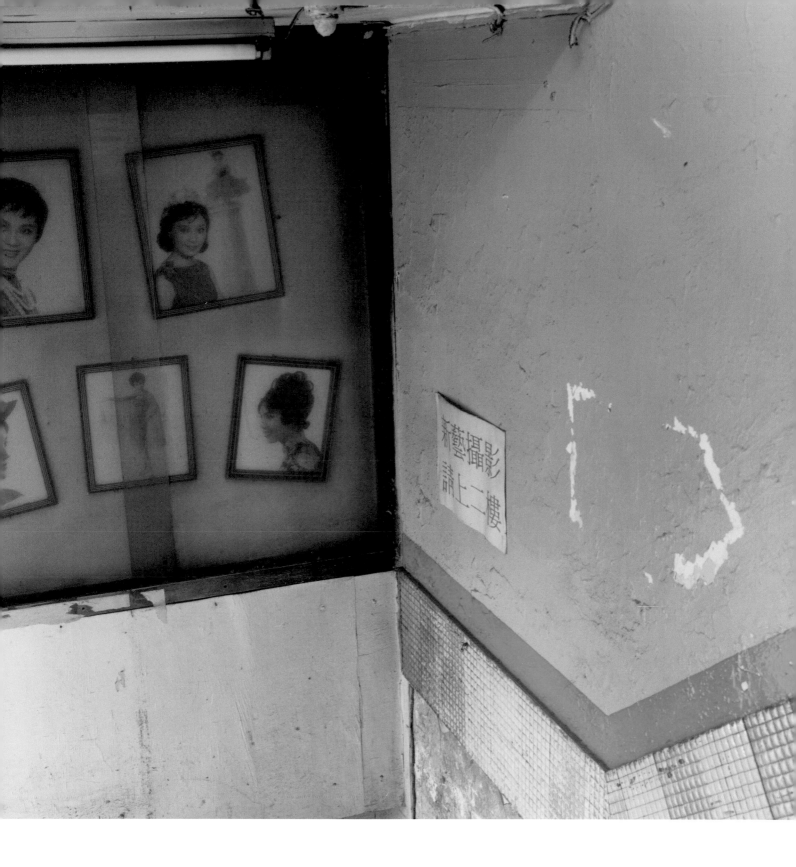

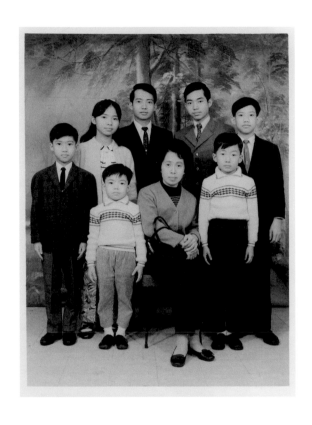

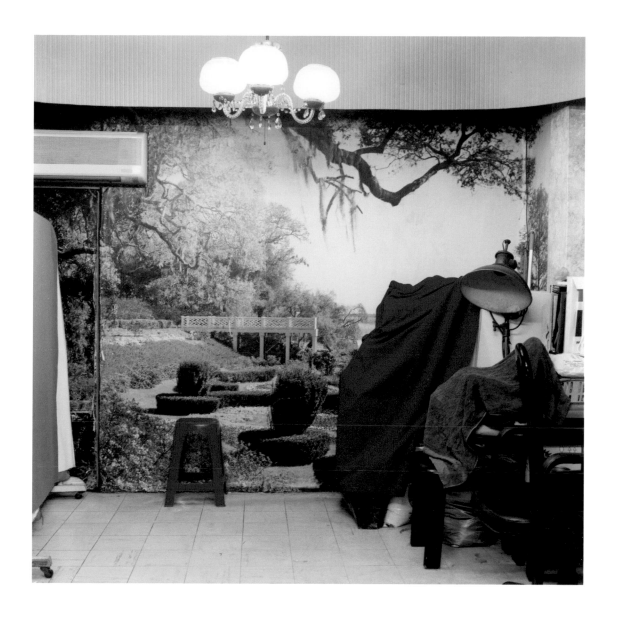

Before emigrating, it was difficult deciding what to take and
what to leave. Kiu Yu picked the Bonsai whilst Chun Yu
insisted on bringing the framed Great Wall of China. When we
got to England, the Bonsai was confiscated. They pointed at
the soil stuck on the roots and took the plant away.

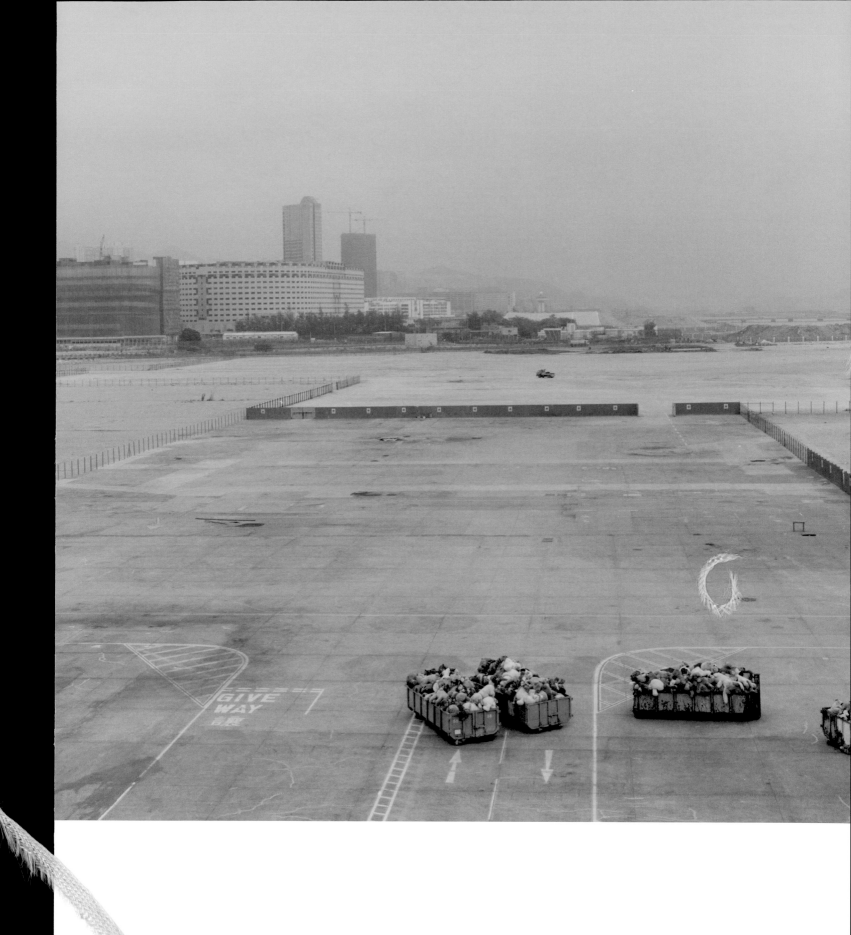

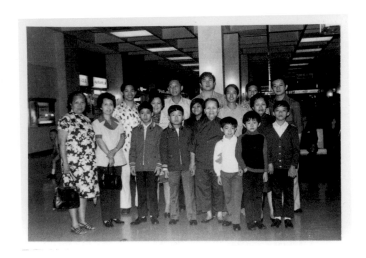

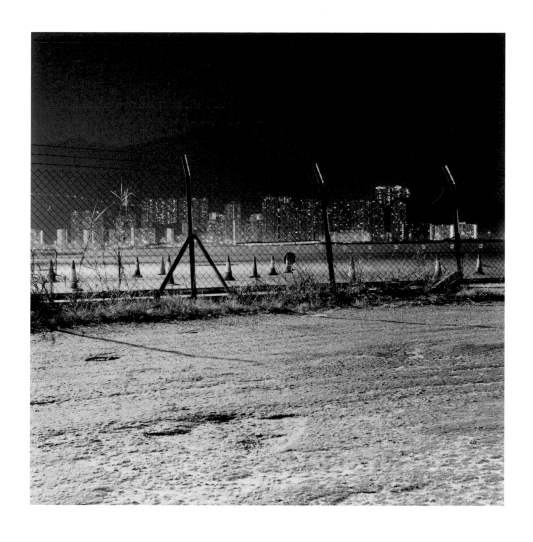

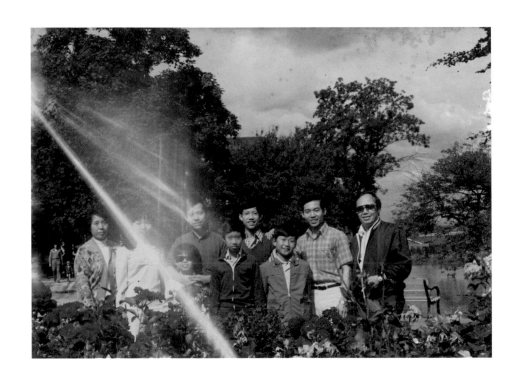

The first thing we learnt was how to make a cup of tea.
We watched in concentration as your dad put milk and two
spoons of sugar in the cup.

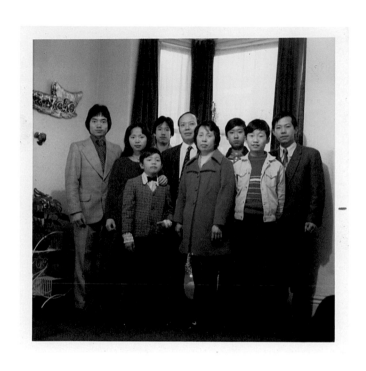

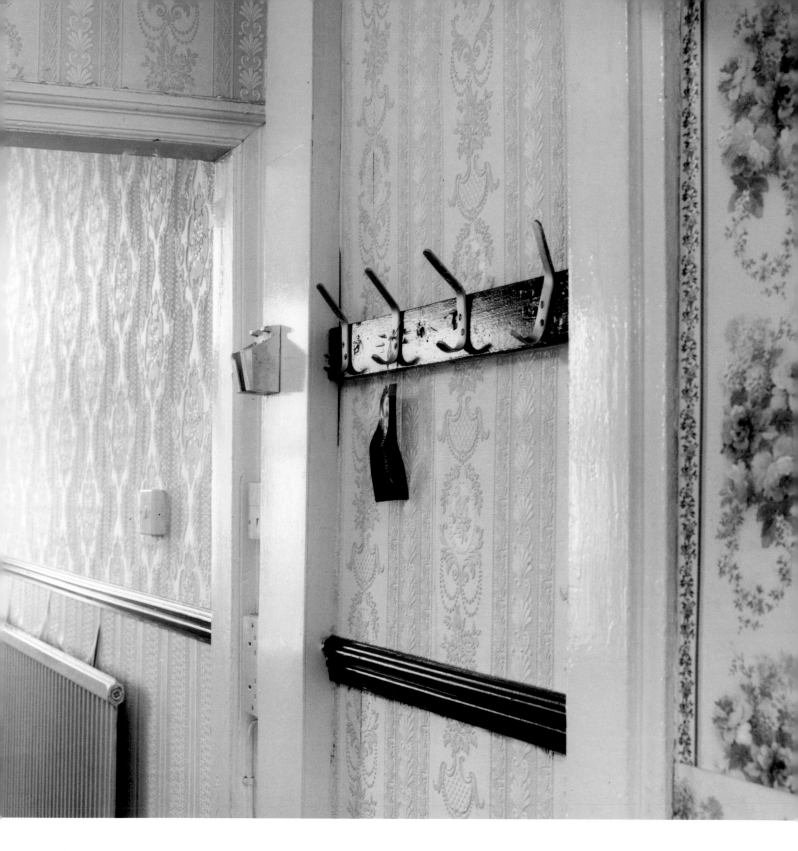

Nobody dared try their English out at the cornerstore. Eventually,
you ran over and came back with a pack of salted peanuts.

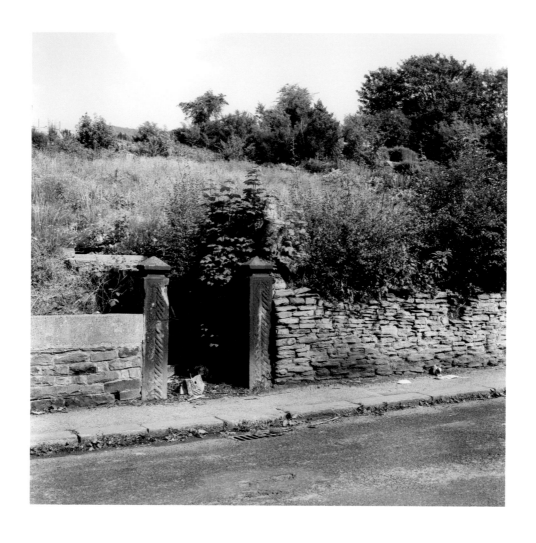

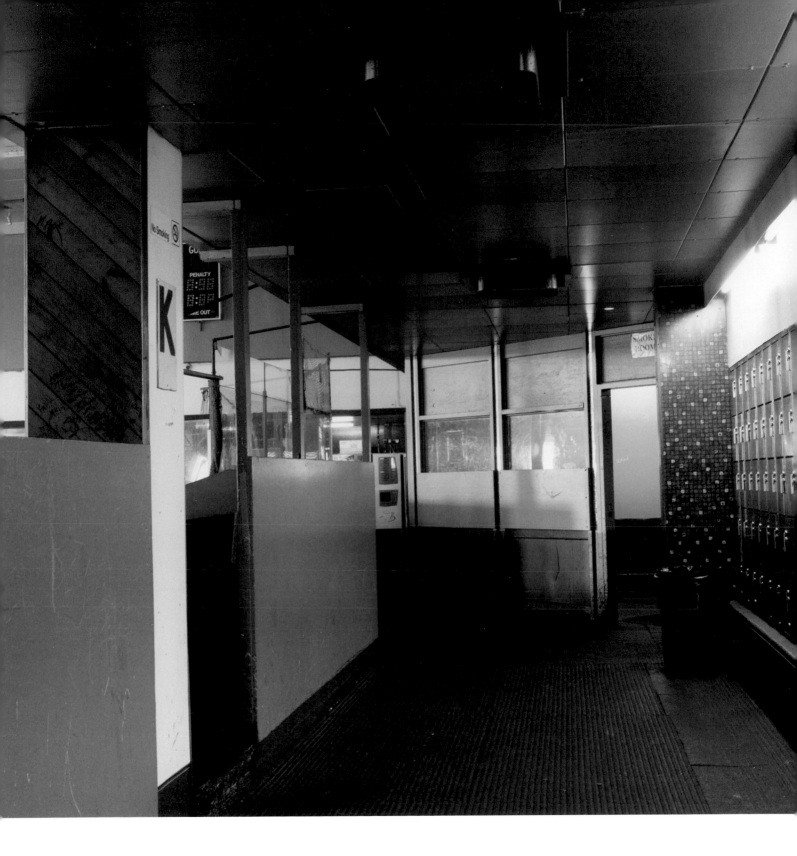

I thought your dad was taking me to see a Shakespeare play, but these half naked men got into the ring and started throwing each other on the floor. They had names like *Big Daddy* and *Giant Haystacks*.

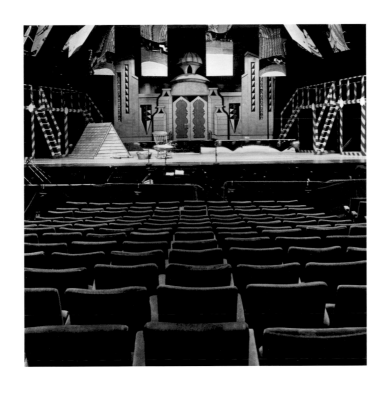

ach dbl tr on hook, thread
through all loops on hook,
a cluster made), * 4 ch,
t 3 ch sp, 4 ch, miss first
up, 1 dbl tr into each of
rking off as for a cluster ;
round ending with 4 ch,
3 ch sp, 4 ch, join with
rst cluster.

* miss first 3 of 4 ch.
ch, 1 dbl tr into each of
dbl tr into next ch, 4 ch,
of next cluster, 4 ch ;
ll round omitting last
t end of last repeat, join
of 8 ch.

, miss first dbl tr of next
to each of next 5 dbl tr

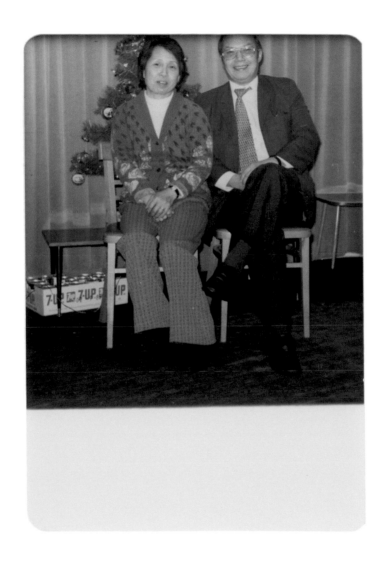

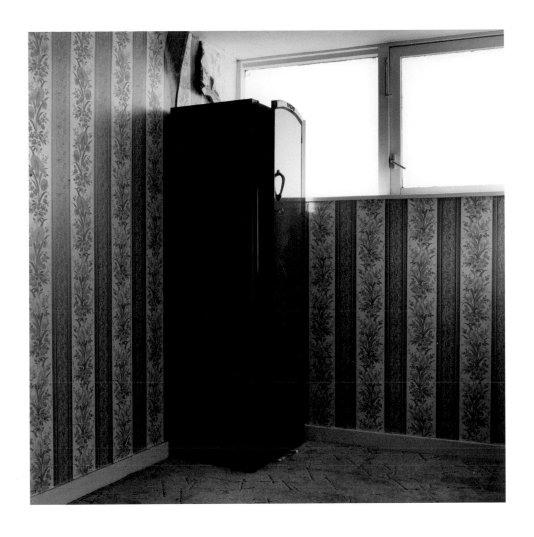

It wasn't long before you started showing me quicker routes to school.

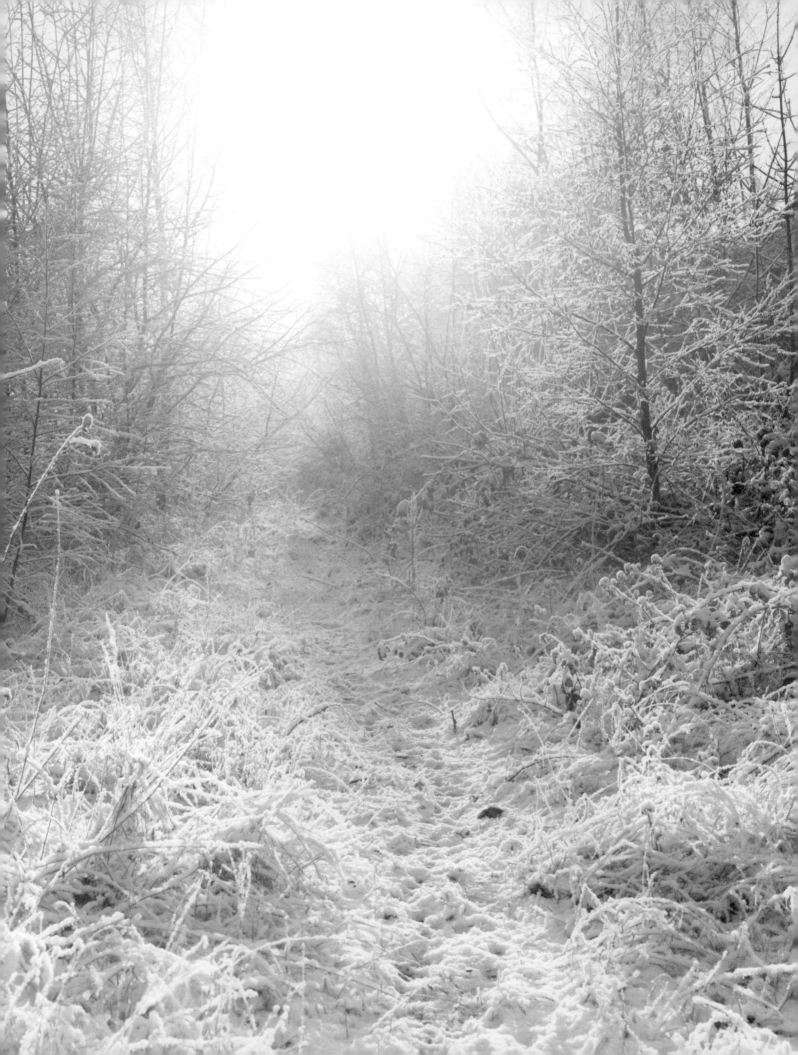

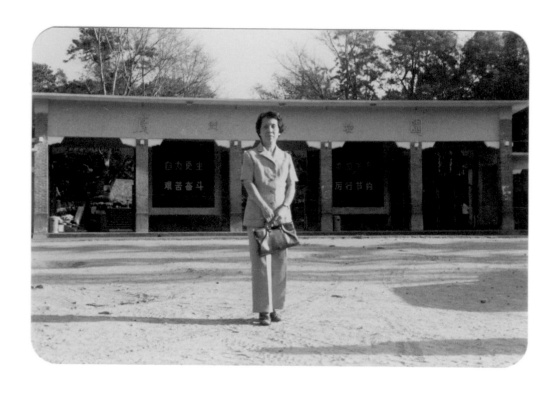

Kiu Yu would practise Tai Chi everywhere. Starting from his bedroom, then along the corridor and finally down to the kitchen. Sometimes I had to open the door for him to continue out the back alley.

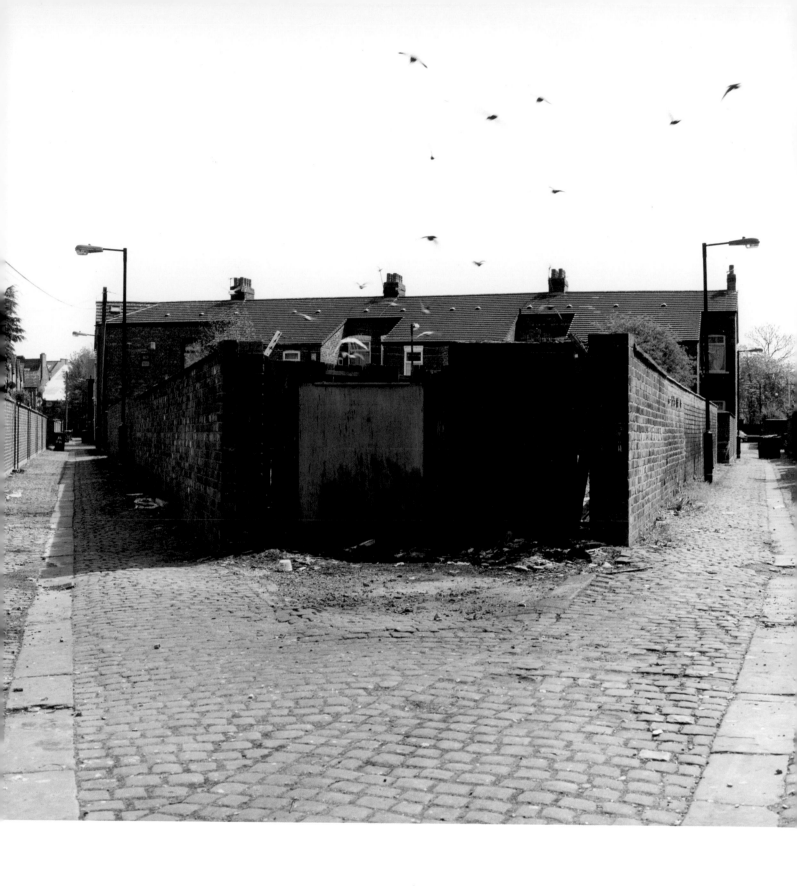

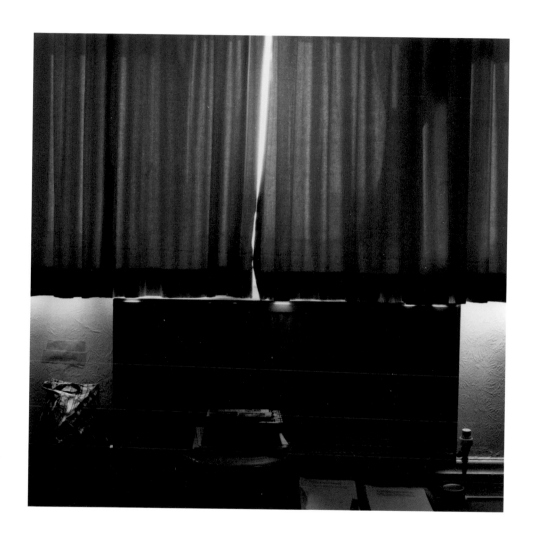

A lady kept looking at me as we waited. In the end, she walked over to talk to me. It was a surprise, but as soon as she spoke, I knew she was from my hometown.

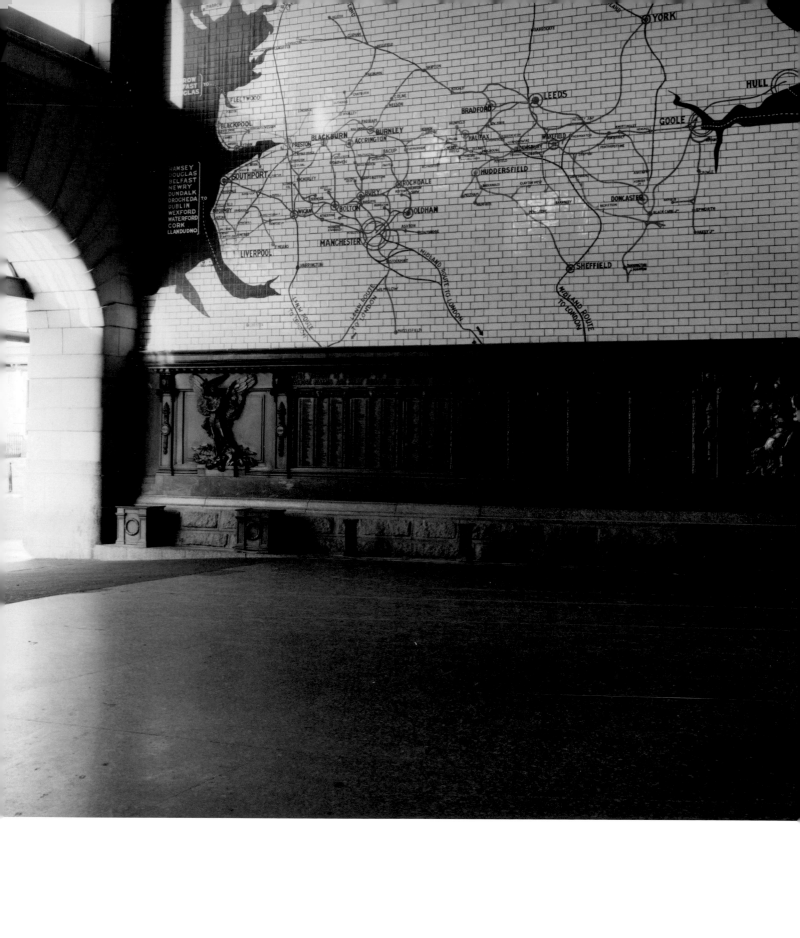

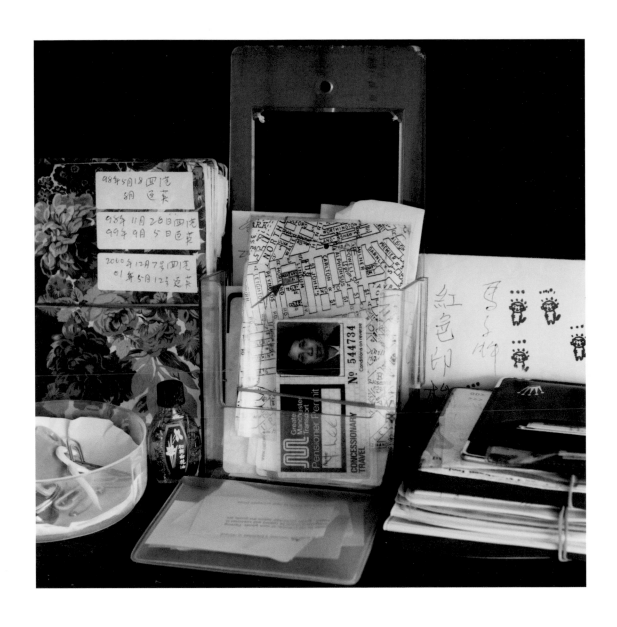

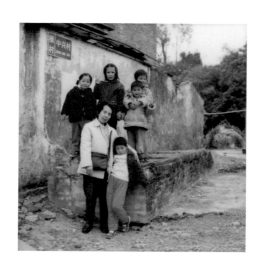

The newspaper suggested a half hour walk each day. Last year, it took me 512 steps from the front door to the shops and 519 steps to get back. Now it takes 518 to get there and 527 to get back.

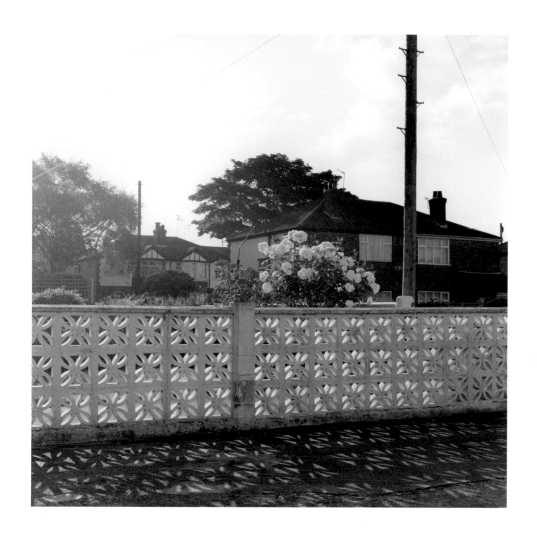

REMEMBERING FOR ANOTHER:
ON DINU LI'S THE MOTHER OF ALL JOURNEYS

In *The Adventures of a Photographer*[1] Italo Calvino recounts the story of Antonino Paraggi, a young man who is strident in his belief that photography cannot capture an accurate sense of a person. He feels that it is impossible to reduce an individual to a single image, convinced that the relationship between photography and memory is rooted in failure. Any attempt to reflect someone he knows would bear no correspondence to his own experienced recollections. The bond between photography and memory — used by Kodak in its first advertising campaign — is one difficult to cleave apart.

Calvino's subject watches his friends as they begin to have children and become increasingly determined to possess the present through the camera. Correspondingly, Antonino becomes progressively more agitated by the activity. He worries that photography implies that events not imprisoned by the camera are regarded as lost; moments that are forgotten as if they had never existed, that eventually become wiped from memory. When asked to take a photograph of two friends he retorts, camera in hand: "what drives you two girls to cut from the mobile continuum of your day these temporal slices, the thickness of a second." For Antonino, the obsession with photography indicates a loss of experience and a momentary lapse of engagement with the surrounding world. Yet over time, and in spite of himself, Antonino begins to photograph, attempting to create the ideal portrait of his friend Bice. He is persistently met with unsatisfactory results. In

attempting to reflect a truthful likeness of Bice he finds himself relying on what he already knows about the person. The point of pressing the shutter is far from a decisive moment: instead it is a present yearning for a remembered past. He finds himself posing his subject to match with the past, as if he is "trying to photograph memories, or a rather vague recollection surfacing in the memory." Antonino becomes convinced that taking a photograph is a refusal to live in the present; it is an activity grounded in chasing a future past.

The filmmaker Chris Marker has spoken of his desire to capture an endless series of memories, in which each fragment can somehow create its own caption. Memory is not a facsimile of the past — it is constantly under construction in order to fulfil one's desires of the past in the present. Actual experiences become stories that are retold, repeated, half-remembered and reconstructed. Sometimes the memories of others become our own, as narratives weave through what we have experienced ourselves. In this way, memory operates as a kind of documentary-fiction: in that it is linked to the past and objective fact, yet rewritten in a continuous present. Photography and film play a strong part in the memory construction process — we can look at photographs and confidently announce "I remember that," but the "that" in question may well be outside of our direct experience. Such a process takes place in both personal and political histories as the present

1 Italo Calvino, *The Adventures of a Photographer*, 1955 in *Difficult Loves*, Vintage, 1999, pp.40–52

defines the past, whilst at the same time the past reconfigures the present through the ways in which it is communicated.

Chris Marker's own elusive practice circulates through anecdote as much as direct experience, with rumour feeding into the work itself as it becomes distributed through recollection and second-hand experience. This double existence is the subject of many of his works. *Sans Soleil* (1983), for example, is a film which both collects fragments of memory and moves between them. From different locations around the world, it collages and composes images and descriptions, narrated by an unseen traveller. Reflecting on the film, Marker states: "I remember that month of January in Tokyo — or rather I remember the images I filmed in that month of January in Tokyo. They have substituted themselves for my memory — they are my memory. I wonder how people remember things who don't film, don't photograph, don't tape? How has mankind managed to remember? I know — the Bible. The new bible will be the eternal magnetic tape of a time that will have to re-read itself constantly just to know it existed."[2] His earlier film *La Jetée* (1962) explicitly considers how images can pull their viewers into different time frames. The film begins with the announcement: "this is the story of a man marked by an image from his childhood." This, the only entirely fictional work by Marker, set sometime in the future, describes how an unnamed man's personal history led him to become selected to take part in an experiment into time-travel, in order to assist the present. As the film explains: "The aim of the experiments was to send an emissary into time to summon the past and future to the aid of the present. But the mind balked at the idea. To awaken in another age was to be born again, fully grown. The shock was too great. So, having failed repeatedly, the experimenters began selecting subjects given to strong mental images. Having a memory of a certain time, they might be able to reinhabit it. This man was chosen because of his obsession with an image from the past."

Dinu Li's photographic essay *The Mother Of All Journeys* interrogates the relationship between photography and memory, continuously reframing the past through the present and the present through the past. On a descriptive register, this project reflects the journey of a UK-based artist with his mother to her family home in rural China. The artist's mother, Yeuk Ling Li, left the village for the British colony of Hong Kong during China's Great Leap Forward in the 1950s, and moved to Sheffield with her children (including Dinu Li), following her husband who had left earlier to establish a base for the family. Later, the family moved again to settle in Manchester. Dinu Li collides images he took while on this journey to places that his mother held in her memory, with family snaps and commentaries from his mother, who tenderly remembers details — of the children finding England easier than she did, of falling in love, of her grandparents. Such an objective account, though,

2 Catherine Lupton, *Chris Marker: Memories of the Future*, Reaktion Books, 2005

does little to convey the complex subjectivities at play. The work simultaneously considers the micro scale of a past shared by a mother and a son that is explored through a journey from England to China, and, on the macro scale, of a voyage from China to England that reflects shifts in the political economy. These two 'conversations' are informed by remembering the past through knowledge of the present.

Dinu Li describes how during the journey he would correct his mother's recollections, convinced he knew better than she did, having heard the stories so many times before. In *The Mother Of All Journeys*, the travelling is led by tales of remembrance rather than by a mapped–out path, whereby a person from one generation tells one from another, stories of their past. Time passes, and the one who was told the stories feels that his memory of the other's past is more accurate, believing that with age, memory becomes unreliable. Together the mother and son visit locations that have both personal and political significance. In each spot a photograph is taken, sometimes referencing old, faded photographs. Together they create a new past and a new present, becoming catalysts for memories. Through someone else's memories, Dinu Li captures a sense of place that will also be unreliable and will itself be informed by telling and retelling. It is as if some kind of time travel operates with the interlacing of frames of memory. In turn, these photographs serve to construct a sense of personal histories that become reworked through their

transmission to strangers As Antonino Paraggi observes, the photograph cannot operate without the influence of memory, and as Chris Marker suggests, direct and indirect experiences merge through the marrying of the image and memory.

Lisa Le Feuvre
Curator and Writer

TRAVELLING BACKWARDS

Dinu Li's decision to make an arduous journey with his mother, aimed at turning actual memories or stories into a lived and shared visual experience, is a complex psychological and physical process to endure. The need for children to tell their parents' story is a powerful desire. Most children get great satisfaction listening to family stories relayed to them by their parents, even if the stories change in some slight detail with each repetition. Eventually the stories are deposited and become owned or translated in a different way, transforming into a new currency. It is understood that somewhere in the many different versions of the past, there is a variant 'truth', mixed with a degree of exaggerated personal drama, depending on when, where and how a story is being told.

If we repeatedly return to an image, it will change in degree by our experience. "Hence the charm of family albums. Those grey or sepia shadows, phantom like and almost undecipherable, are no longer traditional family portraits but rather the disturbing presence of lives halted at a set moment in their duration, freed from their destiny; not, however, by the prestige of art but by the power of an impressive mechanical process: for photography does not create eternity, as art does, it embalms time rescuing it simply from its proper corruption."[1]

We bring more time and experience with each visit to an actual photographic object. Whilst it remains the same, we shift through time and change with experience. Inevitably, we bring new readings to the embedded image and read the same signs with a lesser or greater degree of clarity. New signs are observed as old signs are erased.

The old family photograph is a potential site of torment, constantly re-signifying and referring to a time before you either existed or can remember. The placing, or depositing, of the family archival photograph has not been your responsibility: it has been passed on along with other family baggage. The challenge is to try and make sense of the presence of personal history through the photograph, before some of the key players disappear. Trying to make meanings out of a family history through the photographic object is an ongoing process. It plays to the fantasy of being able to hold on to the past. It delays the fact of the departing. It pretends the past is present. It allows the viewer to imagine they have a fixed purchase on a transient set of images. Dinu Li has chosen the most difficult way to travel — backwards. Photography comfortably aids the desire to look into the past. It has a "detachable nature, which allows it to refer to an absent object separated from it in space and time."[2]

How many migrants of Dinu Li's mother's generation make the return journey home? Photographs are passed on and carried across the borders of personal memory, attended by narratives that, like the photographs themselves, are not fixed in meaning.

1 Andre Bazin, *The Ontology of the Photographic Image*, in *Classic Essays on Photography*, edited by Alan Trachtenberg, Leete's Island Books, 1980

2 Tom Gunning, *Tracing the Individual Body: Photography, Detection, and Early Cinema*, in *Cinema and the Invention of Modern Life*, edited by Leo Charney and Vanessa R Schwartz, Berkeley, University of California Press, 1995

Photographs reveal to us as much as we bring to them. The process of revisiting the past reveals more about the author in the present, than about the subject in the past. When we recall a moment through an old photograph, meanings will always be constructed in the present, as we are only part of the story.

Mark Sealy
Director of Autograph ABP

5

Flight, UK to China

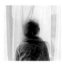

9

Old Trafford,
Manchester, UK

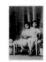

11

Mum 5½, Uncle 4,
1932

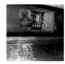

13

Chan Ts'un, Kaiping,
Guangdong, China

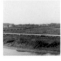

15

Parent's marital home

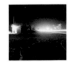

17

Hua Ning Ts'un, Kaiping,
Guangdong, China

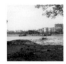

19

Di Hai, Kaiping,
Mum's hangout

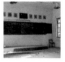

21

Disused cinema

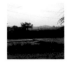

23

Mum's old classroom

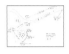

24

Mum's birthplace

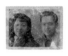

26

Map of origin, drawn
with the help of local
villagers

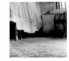

28

Parents first portrait
together 26th January
1944

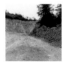

30

Route between mum
and dad's villages

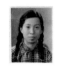

31

Li clan territory

32

Communist hairstyle
6th April 1954

33

Mum's curtain

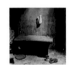

35

Newly arrived in Hong
Kong. Posing next to
a stranger's car, 1956

37

First home in Hong Kong

39

Back of old receipt.
Mum's drawing to me

41

Star Ferry Terminal
Kowloon

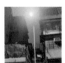

42

Mother and I. 1968

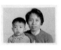

44

My birthplace

47

Favourite cinema

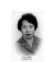

48

1972

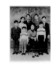

49

Local portrait studio

50

December 1970

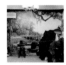

51

Inside studio

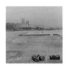

53

Disused airport, Kai Tak,
Hong Kong

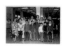

54

Departure lounge,
5th May 1973

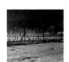

55

Disused airport, Kai Tak,
Hong Kong

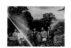

56

First week in UK.
Weston Park,
Sheffield, 1973

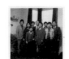

58

First home in UK

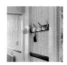

60

Luina's engagement.
1974

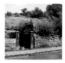

61

Sheffield

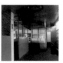

63

Cornerstore, Albert Road

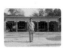

65

Queens Road Ice Ring

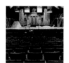

67

City Hall

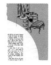

68

Crochet patterns for
dressing table

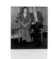

69

Christmas party

71

Our wardrobe and carpet

73

Wasteland by
disused railway line.
Manchester

75

First time back in 7 years.
1980

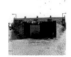

77

Back of Khartoum Street,
Manchester

79

Spare bedroom

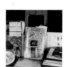

81

Victoria Train Station,
Manchester

82

Travel pass, map,
Chinese ointment,
calendars etc.

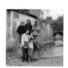

83

Revisiting ancestral
home. Posing with
village girls, 2002

85

Old Trafford, Manchester

SPECIAL THANKS TO

Mum & Dad
My six brothers and sister
My extended family in China and throughout the world

And in alphabetical order

Lothar Albrecht

Kate Best

Sian Bonnell

Camilla Brown

Chris Burns

Will Carr

Sarah Champion

Eddy Chan

Suki Chan

Darren Ching

Graeme Cooper

James Corazzo

Charlotte Cotton

Michael Dyer (and his A team)

Lisa Le Feuvre

Final Film

Sarah Fisher

Marsha Glebova

Anne Hardy

Andrea Hawkins

Graham Holt

Kathy Rae Huffman

Bill Hunt

Li Juan

Greg Leach

Dewi Lewis

Charlie Meecham

Ute Noll

Simon Norfolk

Pippa Oldfield

John Perivolaris

Laura Pottinger

Jimo Toyin Salako

Mark Sealy

P Elaine Sharpe

Claudia Stein

Mariko Takeuchi

Helen Wewiora

Tim Wride

Xinran

First published in the United Kingdom in 2007
by Dewi Lewis Publishing.

Dewi Lewis Publishing
8 Broomfield Road, Heaton Moor,
Stockport SK4 4ND, England.
www.dewilewispublishing.com

Design: James Corazzo
Production: Dewi Lewis Publishing
Print: EBS, Verona, Italy

ISBN: 9781904587415

SUPPORTED BY